SpringerBriefs in Fire

T0281365

Series Editor

James A. Milke

For further volumes:
http://www.springer.com/series/10476

Enrico Ronchi • Daniel Nilsson

Assessment of Total Evacuation Systems for Tall Buildings

 Springer

Enrico Ronchi
Department of Fire Safety Engineering
Lund University
Lund, Sweden

Daniel Nilsson
Department of Fire Safety Engineering
Lund University
Lund, Sweden

ISSN 2193-6595 ISSN 2193-6609 (electronic)
ISBN 978-1-4939-1073-1 ISBN 978-1-4939-1074-8 (eBook)
DOI 10.1007/978-1-4939-1074-8
Springer New York Heidelberg Dordrecht London

Library of Congress Control Number: 2014940142

Printed on acid-free paper

Springer is part of Springer Science+Business Media (www.springer.com)

Foreword

Building evacuation strategies are a critical element in high-rise building fire safety. Research to date has focused on elevators and exit stairs; however, there is a need to apply this research to relocation and evacuation systems, which may include combinations of these two exit strategies as well as new egress components such as sky-bridges for tall buildings.

Accordingly, the Fire Protection Research Foundation initiated this project with the objective to study possible improvements to life safety of tall buildings through an investigation of occupant relocation and evacuation strategies involving the use of exit stairs, elevators, sky-bridges and combinations thereof. The study consists of a review and compilation of existing information on this topic as well as the conduct of case study simulations of a multi-component exit strategy. This review provides the architectural design, regulatory, and research communities with a more thorough understanding of the current and emerging evacuation procedures and possible future options.

The Research Foundation expresses gratitude to the report authors Enrico Ronchi, PhD, and Daniel Nilsson, PhD, who are with Lund University located in Lund, Sweden. The Research Foundation appreciates the guidance provided by the Project Technical Panelists and all others who contributed to this research effort. Special thanks are expressed to the National Fire Protection Association (NFPA) for providing the project funding through the NFPA Annual Code Fund.

The content, opinions and conclusions contained in this report are solely those of the author.

Preface

This report focuses on the use of egress models to assess the optimal strategy in the case of total evacuation in high-rise buildings. A model case study made of two identical twin towers linked with two sky-bridges at different heights has been simulated. The towers are 50-floor high-rise buildings including both vertical and horizontal egress components, namely stairs, occupant evacuation elevators (OEEs), service elevators, transfer floors and sky-bridges. The total evacuation of the single tower has been simulated employing seven possible strategies.

The configuration of the egress components depends upon the evacuation strategy under consideration. The strategies include use of either only one type of vertical egress components (stairs or elevators) or a combination of vertical components (stairs and elevators) or a combination of vertical and horizontal components (stairs, elevators, transfer floors and sky-bridges).

This report presents the general characteristics of the model case study, i.e. the layout of the building and the available egress components in relation to the strategy employed. The evacuation strategies have been simulated employing a continuous spatial representation evacuation model (Pathfinder). In order to provide a cross-validation of the results produced by Pathfinder, a fine network model (STEPS) has been employed to simulate the base case (only stairs available for the evacuation) and one scenario including the use of OEEs.

The comparison between the models has been made employing specified calculations, i.e. the configuration of the inputs of the models is based on complete information about the model geometry, occupant characteristics, etc. Results show that the range of variability of the results between the two sub-models for stair and elevator modelling allows performing a relative comparison between the evacuation strategies.

Differences are dependent on the modelling approaches and the sub-models for stairs and elevators employed by the models. The relative comparison between the strategies has been made using Pathfinder. Strategies involving the use of Occupant Evacuation Elevators (OEEs) are not effective if not linked to appropriate information to occupants about elevator usage, i.e. the accepted waiting time for elevators is

lower than 10 min. The strategy employing only OEEs for the evacuation is the most efficient strategy. If occupants use sky-bridges to evacuate the building, evacuation times would be significantly lower than the strategies involving the use of stairs only or a combination of elevators and stairs without appropriate information to the evacuees.

Lund, Sweden Enrico Ronchi
 Daniel Nilsson

Acknowledgements

The authors thank the Fire Protection Research Foundation via the National Fire Protection Association for sponsoring the production of this material. The authors would also like to thank the Fire Protection Research Foundation (FPRF) for sponsorship of the Project Technical Panel. The members of the Technical Panel are listed here:

- Kristin Bigda, NFPA Staff Liaison
- Kim Clawson, Clawson Consultants
- Rita Fahy, NFPA
- Morgan Hurley, SFPE
- Jay Popp, Lerch Bates, Inc.
- James Shea, Tishman Speyer
- Jeff Tubbs, Arup
- Peter Weismantle, Adrian Smith + Gordon Gill Architecture
- Nate Wittasek, Exponent
- Steve Wolin, Code Consultants, Inc.

The authors wish to thank Amanda Kimball and Kathleen Almand from the Fire Protection Research Foundation to provide technical support on the project. The authors thank the Technical Panel of the project for their guidance during this study. In particular, the authors wish to thank Kim Clawson, Jay Popp and Pete Weismantle for their valuable help in the design of the model case study. The authors thank the model developers for providing educational licenses of their software for this study. Special thanks are also due to Erica Kuligowski for her valuable suggestions.

Contents

1 **Introduction** .. 1

2 **Method** .. 5

3 **Limitations** ... 7

4 **Model Case Study** ... 9
 4.1 Geometric Layout and Egress Components 11
 4.1.1 Configuration of the Floor Plans 11
 4.1.2 Stairs .. 13
 4.1.3 Elevators... 15
 4.1.4 Transfer Floors and Sky-Bridges 17
 4.2 Evacuation Strategies ... 17
 4.3 Application of Evacuation Models .. 21
 4.3.1 Pathfinder ... 23
 4.3.2 STEPS .. 24
 4.3.3 Model Input Calibration.. 28
 4.3.4 Model Results .. 34

5 **Discussion**.. 39

6 **Future Research** .. 43

7 **Conclusion** .. 45

Appendix .. 47

References .. 49

Contributors

Kristin Bigda, NFPA Staff Liaison
Kim Clawson, Clawson Consultants
Rita Fahy, NFPA
Morgan Hurley, SFPE
Jay Popp, Lerch Bates, Inc.
James Shea, Tishman Speyer
Jeff Tubbs, Arup
Peter Weismantle, Adrian Smith + Gordon Gill Architecture
Nate Wittasek, Exponent
Steve Wolin, Code Consultants, Inc.

Project Sponsor

National Fire Protection Association

Nomenclature List

EMR: Elevator machine rooms
FSAE: Fire Service Access Elevators
IBC: International Building Code
MEP: Mechanical Electrical and Plumbing
NFPA: National Fire Protection Association
NIST: National Institute of Standards and Technology
OEE: Occupant Evacuation Elevators
SFPE: Society of Fire Protection Engineers
STEPS: Simulation of Transient and Pedestrian movementS

Chapter 1
Introduction

Building codes such as the International Building Code (IBC 2012) establish the minimum requirements for the safe design of a high-rise building. Nevertheless, additional life safety measures are often necessary to mitigate the risks that arise from the complexity of these types of buildings and the possible difficulties in fire-fighting and rescue operations.

Recent events such as the World Trade Centre evacuation have raised a greater sense of awareness on this topic (Averill et al. 2005). This event has resulted in a paradigm shift in the assessment of high-rise building safety. It demonstrated the importance of providing robust means of egress and the need for further investigating the interactions between the infrastructure, the evacuation procedures and the behaviour of the occupants (Galea et al. 2008a).

Several questions have been prompted about the adequacy of the current emergency procedures for high-rise buildings. What type of evacuation scenarios should be considered when designing high-rise buildings? What egress components (e.g., stairs, elevators, refuge floors, sky-bridges, etc.) are suitable to evacuate high-rise buildings? What emergency procedures should be employed to improve evacuation efficiency? All these questions do not have simple answers and they often depend on the specifics of the building under consideration (Sekizawa et al. 2009). The role of safety designers is made even more difficult by the fact that there is still a lack of knowledge about occupants' behavioural processes that may take place during the evacuation of a high-rise building (Kuligowski 2011).

If a model user is aware of the intrinsic limitations of these models and the subsequent variability of the results, egress models are efficient tools to analyse and compare different evacuation strategies (Machado Tavares 2009). They can be used to provide qualitative and quantitative information on occupant's use of different egress components and strategies. They can in fact allow the representation of the occupant's decision making process in the case of complex evacuation scenarios (Gwynne et al. 1999).

E. Ronchi and D. Nilsson, *Assessment of Total Evacuation Systems for Tall Buildings*,
SpringerBriefs in Fire, DOI 10.1007/978-1-4939-1074-8_1,
© Fire Protection Research Foundation 2014

Previous modelling research has investigated the benefits associated with the use of egress strategies including alternative egress components, i.e. occupant evacuation elevators. Egress simulators including elevators have been developed since the 1970s, including tools suitable for the analysis of total evacuation strategies (Bazjanac 1977). During the 1990s, Klote and Alvord (1992) focused on investigating the feasibility of using evacuation elevators by comparing the evacuation times obtained employing different egress components. The combined use of stairs and elevators were also investigated and the conclusions stated that evacuation elevators may represent a substantial improvement in the safety design of high-rise buildings. Recent research (Wong et al. 2005) investigated the effectiveness of egress strategies in high-rise buildings including both stairs and elevators using egress modelling tools, including the impact of human factors (Kinsey 2011). Those studies all present useful findings on the possible improvements for life safety in high-rise buildings due to the use of elevators for evacuation. The present research extends the current understanding on this issue by providing a qualitative comparison between seven egress strategies, including the combined use of vertical and horizontal egress components. In addition, the present work employs egress modelling to study the effectiveness of ideal hypothetical egress strategies (e.g., the use of sky-bridges or the sole use of evacuation elevators), which have not been investigated in previous research.

A project has therefore been carried out in order to investigate the effectiveness of different total evacuation strategies in high-rise buildings by means of egress modelling (Ronchi and Nilsson 2013a; Ronchi and Nilsson 2014). The scope was to obtain recommendations on future possible changes in the existing codes. This document presents the results of this project.

The present document presents the analysis of seven total evacuation strategies among the most used in the current high-rise building practice. The case study building is a hypothetical building which permits the testing of different egress design configurations. The building is made of two identical twin towers, each made of a 50 floor office building. The two towers are linked with two sky-bridges at different heights. The strategies under consideration include a single or combined use of egress components, such as stairs, occupant evacuation elevators, service elevators used as shuttles, transfer floors and sky-bridges. Two egress models have been applied to simulate the strategies, namely Pathfinder (Thunderhead Engineering 2012) and STEPS (Mott MacDonald Simulation Group 2012). The models employ two different modelling approaches to simulate people movement, i.e. Pathfinder represents the movement of the agents using a system of coordinates (i.e. it is a continuous model), while STEPS simulates the movement in a grid (i.e. it is a fine network model) (Kuligowski et al. 2010). The comparison of the results of two models using different modelling approaches allows providing a cross validation between the model results.

A set of objectives were defined in order to use the predictive capabilities of evacuation models to study the effectiveness of different total evacuation strategies for high-rise buildings:

1. To review the capabilities, assumptions and limitations of two evacuation models to simulate high-rise building evacuations which involve different egress components.
2. To compare a set of evacuation configurations and egress strategies by using evacuation modelling tools.
3. To provide suggestions and recommendations for improving the evacuation efficiency of high-rise buildings.

Chapter 2
Method

The method employed in this study is the application of evacuation modelling techniques. The initial phase of the study is therefore the selection of the appropriate egress models to simulate the total evacuation of high-rise buildings. In particular, the model case study includes the simulation of a combined use of egress components such as stairs and elevators. A recent review (Ronchi and Nilsson 2013b) identified two models having different modelling approaches that are suitable for testing the effectiveness of egress strategies in high-rise buildings. These models are Pathfinder (Thunderhead Engineering 2012) (a continuous model) and STEPS (Mott MacDonald Simulation Group 2012) (a fine network model).

There are three different levels to perform evacuation model simulations (Lord et al. 2005), namely open, blind and specified calculations. Those calculations vary the degree of information about the scenarios to be simulated, i.e. information necessary for the calibration of the model input. Blind calculations are based on a basic description of the scenario and the model user has the freedom to decide the additional details needed for the simulation work. Specified calculations employ instead a detailed description of the model inputs. Open calculations are based on actual evacuation data or benchmark model runs from other models that are fully validated for the scenario under consideration. Given the objectives of the present study, the last type of calculation has been performed. Specified calculations are in fact suitable for testing the underlying algorithms of the models and therefore assessing the uncertainty related to the model rather than the user (Lord et al. 2005).

The evacuation model input has been calibrated using experimental data rather than the values provided in the codes or the default settings of the models. This was made in order to simulate as much realistic evacuation scenarios as possible. In addition, the work represents a deliberate attempt to calibrate the models trying to avoid what is generally called in the evacuation modelling community, the *user effect* (Ronchi 2012), i.e., results affected by the choices of the modellers during the process of input calibration. The *user effect* may in fact cause that the predictive

E. Ronchi and D. Nilsson, *Assessment of Total Evacuation Systems for Tall Buildings*,
SpringerBriefs in Fire, DOI 10.1007/978-1-4939-1074-8_2,
© Fire Protection Research Foundation 2014

capabilities of the models are dependent on the modeller's expertise and assumptions, rather than the model sub-algorithms. This is reflected in the possible impact of evacuation model default settings, which has been found in many contexts as a determinant factor of evacuation model results (Gwynne and Kuligowski 2010; Ronchi et al. 2012a, b).

Chapter 3
Limitations

This study focuses on the application of evacuation models to test the efficiency of seven different total evacuation strategies in high-rise buildings. The questions prompted about the suitability of different components and strategies for high-rise buildings are strongly dependent on the characteristics of the building under consideration. In the present work, although the model case study includes the combination of several egress components, the authors acknowledge that a single case cannot be representative of all the possible high-rise building configurations. The selection of the model case study was deliberately made in order to give a vast range of applicability to the findings of this study. For this reason, the characteristics of the model case study have been selected to be representative of today's buildings. Nevertheless, there was the necessity to impose certain features that may significantly affect the results (e.g., building use, number of floors, egress components, etc.).

The model case study has been designed to be compliant with current building codes (e.g. mainly NFPA 101 (NFPA 2012a, b) and International Building Code 2012 (IBC 2012)) with regards to the geometrical layout of the egress components. Nevertheless, fire codes often present inconsistencies in their requirements and it was necessary to make assumptions to fit with the objectives of the present work. For this reason, the model case study should be considered as an ideal case and not as a fully code compliant building.

In any building, there are numerous evacuation strategies that can be developed for the building occupants. In this case, the number of scenarios under consideration has been restricted to the most significant configurations in the current engineering practice. In addition, no information is provided about the times needed to clear each individual floor, i.e., due to the scope of the project, the scenarios are analysing only the case of total evacuation.

The selection of the egress models employed in this study is based on a literature review made on the applicability of evacuation models for high-rise buildings (Ronchi and Nilsson 2013b). The capabilities of evacuation models are constantly evolving (Ronchi and Kinsey 2011) and the subsequent suitability of additional models for the scopes of the projects can vary rapidly. In addition, many evacuation

E. Ronchi and D. Nilsson, *Assessment of Total Evacuation Systems for Tall Buildings*,
SpringerBriefs in Fire, DOI 10.1007/978-1-4939-1074-8_3,
© Fire Protection Research Foundation 2014

models present sufficient flexibility to be employed for high-rise buildings even if they are not able to explicitly represent some of the variables involved. For this reason, the selected models should not be considered as the only suitable models for simulating high-rise buildings, i.e., this study could have been performed also with different models. The choice of the two models employed (STEPS and Pathfinder) was made in order to compare two egress models having different modelling assumptions and that were originally designed to simulate all the egress components involved in high-rise building evacuations.

Chapter 4
Model Case Study

The model case study consists of two towers, each made of 50 floors, with a total height of 207 m (678 ft). The building use is business, i.e., the model is an office building. The high-rise building consists of a lobby (floor 1) and a total of 46 floors designated to office use (from floor 3 to floor 48). The remaining floors are designated for mechanical, electrical and plumbing equipment (MEP floors).

A set of assumptions have been made for the simulation of the model case study:

1. Mechanical floors are required for this type of buildings. Since their impact on egress is minor, they are not taken into consideration in this study.
2. The basements would include loading docks and underground parking. These floors are disregarded from the study since they would have no impact on the evacuation, i.e., they are served by egress components which are separate from those above the ground floor.
3. Assembly areas (e.g., a conference centre on floor 2) are not considered in this study.
4. The inter-distance between the lobby and the first floor designated to office use (floor 3) is approximately 12.2 m (40 ft), i.e., the lobby is an atrium. The floor-to-floor inter-distance between all the office floors is approximately 4 m (13 ft), i.e., from floor 3 to floor 48.
5. An additional space in the floors immediately above the sill of the last stop of every occupant elevator bank is occupied by the machine rooms. This space is equal to the height of two floors immediately above the sill of the last stop served by the elevator, i.e., 8 m (26 ft). The hoistway area of the four elevator bank is about 11.0 m (36 ft) wide and 2.5 m (8 ft) deep. At the machine room floor, the combined area occupied by the machine room is about 11.0 m (36 ft) wide and 5.0 m (16 ft) deep.

Annex 1 provides a summary of the geometric characteristics the different floors (floor-to-floor heights, etc.) and the floor uses.

E. Ronchi and D. Nilsson, *Assessment of Total Evacuation Systems for Tall Buildings*, SpringerBriefs in Fire, DOI 10.1007/978-1-4939-1074-8_4, © Fire Protection Research Foundation 2014

Fig. 4.1 Schematic
representation of the model
case study, a single tower

Fig. 4.2 Schematic
representation of the model
case study, the twin towers

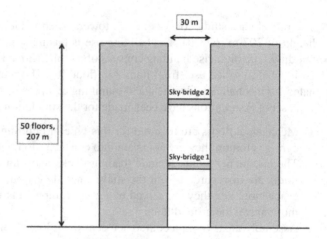

The two towers are either studied as individual buildings (see Fig. 4.1) or linked
by two sky-bridges at different heights. The sky-bridges have a length of 30 m
(98 ft) each (see Fig. 4.2). The two sky-bridges are located respectively at 71.5 m
(235 ft) and 131 m (430 ft) from the ground.

The typical floor plans are constituted by a plate of 42.7 m (140 ft) of length and
65.5 m (215 ft) of width. The total gross area of each plan is therefore approximately
2,797 m² (30,100 gsf). The central part of the typical floor plans is constituted by
a core (see Fig. 4.3), which includes most of the egress components available.
The dimensions of the core are 13.7 m (45 ft) of width and approximately 37 m
(120 ft) of length, for a total of 507 m² (5,400 gsf) (the exact dimensions of the core
change along the height of the building).

The towers can be ideally divided into three zones (see Fig. 4.4), which are
linked with two transfer floors at floor 18 (transfer floor 1) and floor 33 (transfer
floor 2). The low-rise zone is the zone between the lobby and floor 18. The mid-rise
zone is the zone between floor 18 and floor 33. The high-rise zone is in the range of
floor 33 and floor 50.

Fig. 4.3 Schematic
representation of the top view
of the typical floor plan

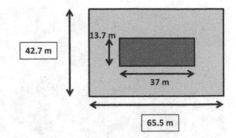

Fig. 4.4 Schematic
representation of the side
view of the building

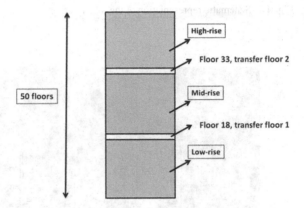

4.1 Geometric Layout and Egress Components

The model building includes different egress components in relation to the evacuation scenarios under consideration. This section provides the information of all the possible means of egress available in the building. The building is provided with either 2 or 3 stairs, 24 occupant evacuation elevators (OEEs) divided in three banks serving three zones (low-rise, mid-rise, and high-rise), 2 service elevators, 2 transfer floors and 2 sky-bridges.

4.1.1 Configuration of the Floor Plans

Figure 4.5 shows a schematic representation of the lobby core, including the possible egress components available in the lobby. The low-rise elevator bank is drawn in red (E1–E8), the high-rise elevator bank is in green (E9–E16), the mid-rise elevator bank is in white (E17–E24). The two service elevators are drawn in blue (se1–se2). Stairs in grey are respectively S1 = stair 1 (located on the left side of the core), and S2 = stair 2 (located in the right side of the core). The stair in yellow is S3 = Stair 3.

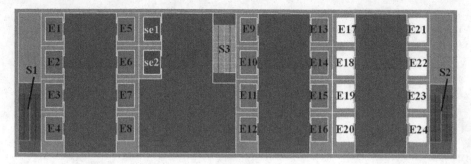

Fig. 4.5 Schematic representation of the lobby core

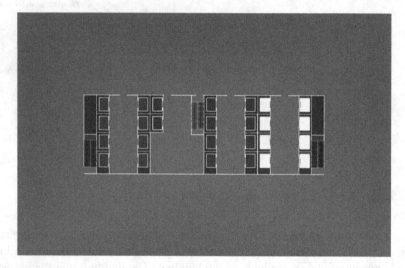

Fig. 4.6 Schematic representation of the lobby

Additional egress components include the availability of transfer floors and sky-bridges at floor 18 (transfer floor 1 and sky-bridge 1) and floor 33 (transfer floor 2 and sky-bridge 2).

Figures 4.6, 4.7, 4.8, 4.9, 4.10, and 4.11 provide a schematic representation of the egress components in the floor plans, i.e., the lobby (Fig. 4.6), the low-rise (Fig. 4.7), transfer floor 1 (Fig. 4.8), mid-rise (Fig. 4.9), transfer floor 2 (Fig. 4.10), and high-rise (Fig. 4.11) typical floor plans. The egress components are represented in accordance with the colour scheme defined in Fig. 4.5. Figures 4.8 and 4.10 embed two transfer floors where sky-bridge entrances are represented in green on the left boundary of the floor plans.

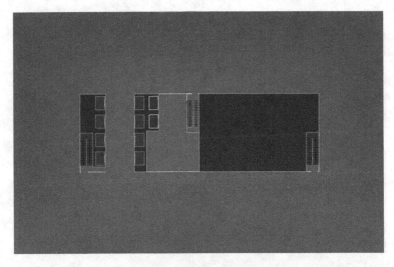

Fig. 4.7 Schematic representation of the typical low-rise floor plan

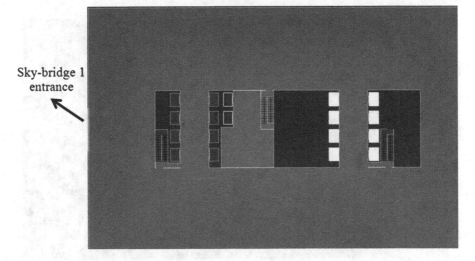

Fig. 4.8 Schematic representation of floor 18, the transfer floor between the low rise and mid-rise zone of the building. The sky-bridge 1 entrance is shown in *green* on the *left side* of the floor plan (Color figure online)

4.1.2 Stairs

The characteristics of the stairs are defined in line with NFPA101 (NFPA 2012a, b). Stair configuration (see Table 4.1) is defined with the minimum stair width, i.e., 1,120 mm (44 in.), the minimum tread depth, i.e., 280 mm (11 in.), and the

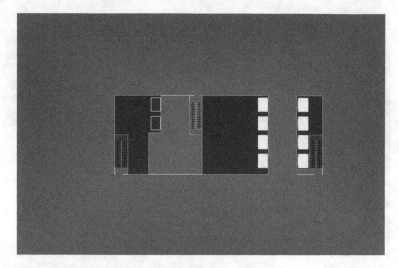

Fig. 4.9 Schematic representation of the typical mid-rise floor plan

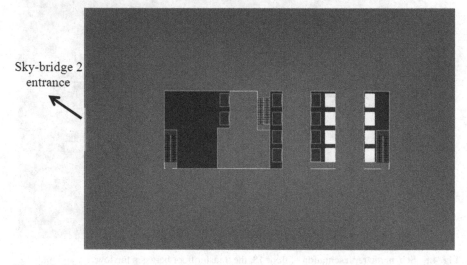

Sky-bridge 2
entrance

Fig. 4.10 Schematic representation of floor 33, the transfer floor between the mid-rise and high-rise zone of the building. The sky-bridge 2 entrance is shown in *green* on the *left side* of the floor plan (Color figure online)

maximum riser height, i.e., 180 mm (7 in.). The requirement of NFPA 101, section 7.2.2.2.1.2 (NFPA 2012a, b) for 56-in. wide (1,420 mm) stairs to be utilized when stairs have a cumulative occupant load of 2,000 or more occupants, has not been utilized in the sizing of the stairs in this study.

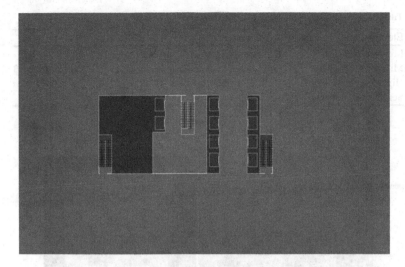

Fig. 4.11 Schematic representation of the typical high-rise floor plan

Table 4.1 Configuration of the stairs

Stair configuration	
Nominal Width	1,120 mm (44 in.)
Tread depth	280 mm (11 in.)
Riser height	180 mm (7 in.)

Table 4.2 Summary of the elevator characteristics

Bank	N. of elevators	Max speed in m/s (fpm)	Acceleration in m/s2 (ft/s2)	Capacity Kg (Lb)	Nominal load (n)	Open + close time (s)
Low	8	4.0 (700)	1 (3.3)	1,814 (4,000)	19	5
Mid	8	8.0 (1,200)	1 (3.3)	1,814 (4,000)	19	5
High	8	9.0 (1,500)	1 (3.3)	1,814 (4,000)	19	5
Service elev.	2	6.0 (1,200)	1 (3.3)	2,041 (4,500)	21	7

4.1.3 Elevators

The OEEs employed in this model case study are the Class "A" office standard elevators (Strakosch and Caporale 2010). Their dimensions are 1.85 m (6 ft) × 2.45 m (8 ft). The entrance doors of the elevator are single speed, with centre opening doors. The dimensions of the elevator entrance are 1.2 m (44 in.) of width by 2.1 m (7 ft) of height. The main characteristics of the elevators with regards to elevator kinematics and nominal loads are presented in Table 4.2.

Table 4.3 Summary of the elevator diagram

Elevator bank	Served floors
Low-rise (E1–E8)	Lobby, Floors 3–17 transfer floor 18
Mid-rise (E17–E24)	Lobby, transfer floor 18, floors 19–32, transfer floor 33
High-rise (E9–E16)	Lobby, transfer floor 33, floors 34–48
Service elevators (se1–se2)	All floors

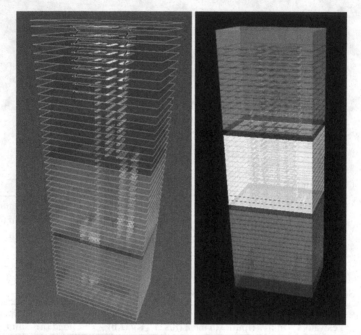

Fig. 4.12 3D model of the single tower represented using Pathfinder (*left*) and STEPS (*right*)

The three elevator banks (low-rise, mid-rise and high-rise) are distributed in order to serve the three zones of the building. Service elevators serve all the floors of the building. Table 4.3 provides a summary on the elevator zoning.

The zoning presented in Table 4.3 is the general diagram of the elevators. The evacuation strategies in the following sections provide further information on the eventual modifications to this configuration in some of the evacuation scenarios under consideration. Figure 4.12 shows the 3D models of the single tower of the case study under consideration. The three elevator zones are identified using different colours (red for the low-rise zone, white for the mid-rise zone and green for the high-rise zone) in accordance with the information provided in Table 4.3. Transfer floors are shown in black.

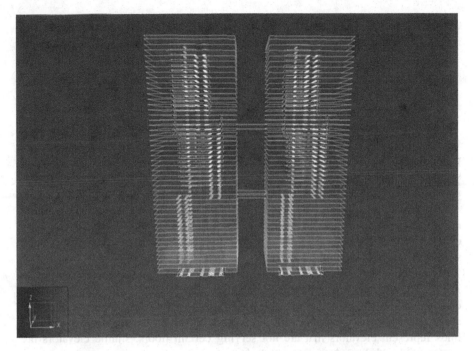

Fig. 4.13 3D model of the twin towers model case study (represented using Pathfinder)

4.1.4 Transfer Floors and Sky-Bridges

Two sky-bridges are placed in correspondence to the transfer floors, namely floor 18 and floor 33 (see Fig. 4.13). Transfer floors are made available since they can accommodate a significant number of evacuees. Therefore, they have the double function of serving as pick up floors for OEEs as well as to providing sufficient space to permit the flow of evacuees using the sky-bridges located in the same floor.

4.2 Evacuation Strategies

This section presents the relocation strategies to be investigated by means of egress modelling. These strategies include the use of either vertical or horizontal egress components as well as their combined use.

The evacuation of the two towers is considered individually, i.e. the hypothetical scenarios consider one tower at time to be evacuated. Nevertheless, the results from one scenario (the scenario including sky-bridges), will be used to provide recommendations on the evacuation of the twin towers.

Table 4.4 Examples of graphical conventions

	It represents the service elevators serving as shuttle.
	It represent a high-rise elevator bank serving all floors
	It represent a low-rise elevator bank that is not serving the floors

Buildings over 36 m (120 ft) are required by both the 2009 IBC (2012) and 2012 NFPA 5000 (NFPA 2012a, b) to have Fire Service Access Elevator (FSAE). In particular, the 2012 IBC and 2012 NFPA 5000 require two FSAEs. The different scenarios will take into consideration this issue by identifying the elevators designated for this purpose.

The relocation strategies are presented in this section using the same convention employed in Fig. 4.5, i.e., S1 = stair 1, S2 = stair 2, S3 = stair 3, E1–E8 = low-rise elevator bank, E17–E24 = mid-rise elevator bank, E9–E16 = high-rise elevator bank, se1–se2 = service elevators.

To facilitate the understanding of the strategies, the colour scheme is the same as in Fig. 4.5, i.e., stair 1 and 2 are shown in grey, stair 3 is shown in yellow, low-rise elevators are shown in red, mid-rise elevators are shown in white, high-rise elevators are shown in green. Continuous lines represent elevators serving all floors. Dotted lines represent elevators that are not serving certain floors, shuttle elevators are represented with lines with dots and dashes.

An example of the convention adopted in the description of the strategies is provided in Table 4.4.

Strategy 1.
This strategy is the base case. Two stairs are the only egress components available (Fig. 4.14).

Strategy 2.
This strategy takes into consideration an additional third stair, i.e. three stairs are available for the evacuation of the building (Fig. 4.15).

Strategy 3.
In line with the IBC 2012 (2012), Section 3008, Occupant Evacuation Elevators (OEEs) allow for the elimination of the additional third stair in buildings over 128 m. This strategy considers then the combination of two stairs and OEEs (Fig. 4.16).

Strategy 4.
This strategy is a hypothetical scenario in which only the Occupant Evacuation Elevators (OEEs) are available for the egress, i.e. stairs are not available for evacuation (Fig. 4.17).

Strategy 5.
This strategy is a combination of 2 stairs (S1 and S2) and Occupant Evacuation Elevators (OEEs). In addition, service elevators are used as shuttles between the transfer floors and the ground. The prescription about FSAEs is not taken into consideration in this hypothetical strategy (Fig. 4.18).

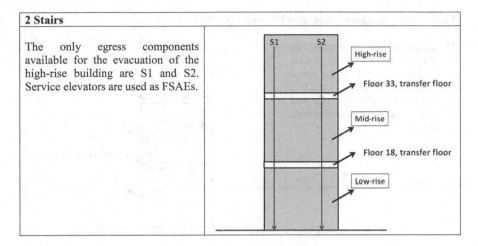

Fig. 4.14 Schematic representation of Strategy 1

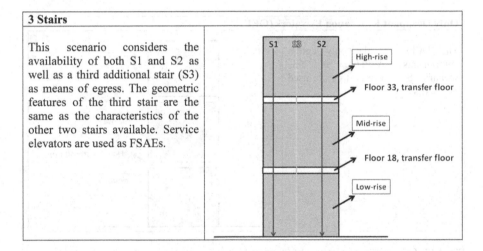

Fig. 4.15 Schematic representation of Strategy 2

Strategy 6.

This strategy is a combination of 2 stairs and Occupant Evacuation Elevators (OEEs). In this case, the mid-rise elevators are split in two groups to serve as shuttles to the transfer floors (Fig. 4.19).

Strategy 7.

This strategy takes into consideration the implementation of two sky-bridges and two transfer floors in correspondence to floor 18 and floor 33. The sky-bridges permit to split the occupants in three groups, namely evacuees through the ground, evacuees through sky-bridge 1 and evacuees through sky-bridge 2. The evacua-

2 Stairs and Occupant Evacuation Elevators (OEEs)

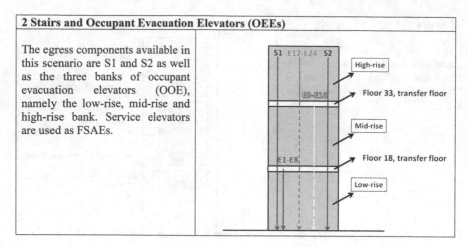

The egress components available in this scenario are S1 and S2 as well as the three banks of occupant evacuation elevators (OOE), namely the low-rise, mid-rise and high-rise bank. Service elevators are used as FSAEs.

Fig. 4.16 Schematic representation of Strategy 3

Only Occupant Evacuation Elevators (OEEs)

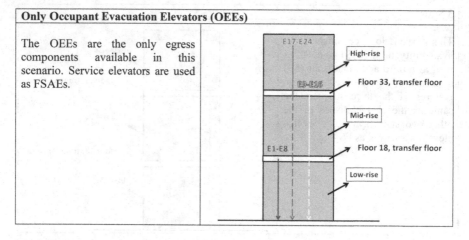

The OEEs are the only egress components available in this scenario. Service elevators are used as FSAEs.

Fig. 4.17 Schematic representation of Strategy 4

tion is considered terminated when the occupants reach either one of the exits on the ground floor or the entrances of the sky-bridges. It should be noted that all occupants from the evacuated tower, who are assembling on the sky-bridge floors of the non-impacted tower, will be able to evacuate that building by utilizing all of the elevators in the non-impacted tower, which will be able to operate in an express mode from the sky-bridge floors to the ground level. This will prevent the accumulation of evacuees on the sky-bridge floor (Fig. 4.20).

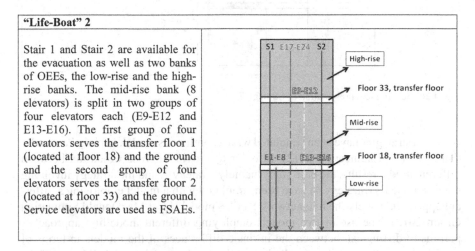

"Life-Boat" 1

S1 and S2 are available for the evacuation as well as all three banks of OEEs. In addition, the two service elevators are serving the two transfer floors and the ground only, being express shuttles between the ground and those floors. Once the two service elevators have emptied the two transfer floors, they are redirected to the other floors with a top-down priority.

S1 E17-E24 S2

High-rise

se2 E9-E16 Floor 33, transfer floor

Mid-rise

Floor 18, transfer floor

E1-E8 se1 Low-rise

Fig. 4.18 Schematic representation of Strategy 5

"Life-Boat" 2

Stair 1 and Stair 2 are available for the evacuation as well as two banks of OEEs, the low-rise and the high-rise banks. The mid-rise bank (8 elevators) is split in two groups of four elevators each (E9-E12 and E13-E16). The first group of four elevators serves the transfer floor 1 (located at floor 18) and the ground and the second group of four elevators serves the transfer floor 2 (located at floor 33) and the ground. Service elevators are used as FSAEs.

S1 E17-E24 S2

High-rise

E9-E12 Floor 33, transfer floor

Mid-rise

E1-E8 E13-E16 Floor 18, transfer floor

Low-rise

Fig. 4.19 Schematic representation of Strategy 6

4.3 Application of Evacuation Models

This section presents the application of two evacuation models for the simulation of the total evacuation strategies described in the previous section. The model case study has been implemented within the models and the model input configuration has been made in line with the description of the scenarios made in the previous section. The selection of the models has been made in line with the literature review made by Ronchi and Nilsson (2013b) about the suitability of evacuation models to simulate high-rise building evacuations.

Sky-bridges

The available egress components are S1, S2, the three banks of OEEs, and two Sky-bridges located in correspondence of two transfer floors (located at floor 18 or floor 33). In this scenario, the OEEs of the high and mid-rise banks are not discharging the occupants in the ground floor. They are instead discharging the occupants in the transfer floors, i.e. the mid-rise elevators are discharging the occupants in floor 18 (i.e., the transfer floor 1), while the high-rise elevators are discharging the occupants at floor 33 (i.e., transfer floor 2). Stair users of the different zones are also split in three groups. They will either evacuate through the ground (low-rise stair users), the sky-bridge 1 (mid-rise stair users) or the sky-bridge 2 (high-rise stair users). Service elevators are used as FSAEs.

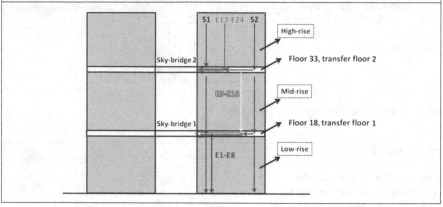

Fig. 4.20 Schematic representation of Strategy 7

Seven strategies have been simulated with a continuous model, namely Pathfinder (Thunderhead Engineering 2012). In order to provide a cross validation between different model results, the base study, namely strategy 1, and the strategy involving the use of OEEs (Strategy 4) have been simulated with a model employing a different approach, namely the fine network STEPS model (Mott MacDonald Simulation Group 2012). The use of two models employing different modelling approaches permits to distinguish between the intrinsic differences of the models in terms of quantitative evacuation time predictions and provide a qualitative validation of the results. The choice of the strategies to be simulated with the second model has been made in order to provide results on scenarios that involve each vertical egress component under consideration in this study (i.e., stairs or elevators). The strategies involving a single egress component have been investigated in order to analyse the underlying stair and elevator sub-models embedded in the tools employed and their different modelling approaches.

Oftentimes models present differences in the inputs to be implemented for the simulation of a particular aspect of the egress process, such as the case of Pathfinder and STEPS. In those cases, the study is based on the use of the input data in common as determinant for the evacuation. This method is employed in order to minimize the differences among the results deriving from the calibration of the model input and highlight the differences depending on the intrinsic characteristics of the models.

X Bounds:	-8,20 ft, -1,64 ft	Riser:	7,0 in	Width:	23,622 in	Area:	23,2859 ft²
Y Bounds:	-0,33 ft, 1,64 ft	Tread:	11,0 in	Top Door:	STAIR_WIDTH	Pers:	0
Z Bounds:	9,84 ft, 19,69 ft	Length:	11,8292 ft	Bot. Door:	STAIR_WIDTH	Density:	0,0 pers/ft²

Fig. 4.21 Screenshot of the stairways input menu in Pathfinder. The values in the figure are not representative of the model input configuration

4.3.1 Pathfinder

Pathfinder 2012 (version 2012.1.0802) is a commercial continuous model developed by Thunderhead Engineering (2012). The movement of the agents is simulated in the model using two different methods. The first method is the hydraulic model provided in the Society of Fire Protection Engineering Handbook (Gwynne and Rosenbaum 2008). The second method is an agent-based model, i.e., the Reynolds (1999) steering model refined by Amor et al. (2006). Agents move along their path using a steering system that allows each agent to interact with the environment and the other agents. In the present study, the steering method has been employed.

Stairs in Pathfinder

Stairs are represented in Pathfinder through straight-run of steps. The model requires the input data about riser, tread and width (see Fig. 4.21). In Pathfinder, the specified tread rise and run are the factors considered in the calculation, i.e., the simulation is not dependent on the geometric slope of the stairs.

Stairways denote areas where the maximum occupant speed is controlled by an alternate specific calculation. In the case of high densities ($D > 0.55$ p/m2), movement up and down stairways is calculated using Eq. (4.1) (Thunderhead Engineering 2012), where the k value (see Table 4.5) depends on the slope of the stairway.

$$v(D) = v_{max} \times \frac{k - 0.266 \times k \times D}{1.19} \tag{4.1}$$

where D is the density and v_{max} is user dependent. Equation (4.1) is used to calculate the speed scale factors.

Elevators in Pathfinder

Elevators in Pathfinder are made of a discharge node and any number of elevator levels. Inputs required by the elevator sub-model are the nominal load, acceleration, max velocity, door open + close time, and the elevator bounds (see Fig. 4.22).

Table 4.5 k values
for stairways movement
in Pathfinder

Stair riser (inches)	Stair tread (inches)	k
7.5	10.0	1.00
7.0	11.0	1.08
6.5	12.0	1.16
6.5	13.0	1.23

Fig. 4.22 Screenshot of the
"create elevator" input menu
in Pathfinder. The values in
the figure are not
representative of the model
input configuration

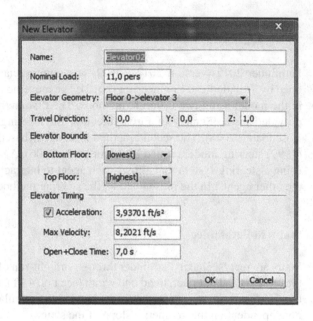

The way-scripting system embedded in Pathfinder permits also to create a set of
additional waiting areas. Those areas can be used for simulating the decision mak-
ing process about a certain egress component. It is also possible to further modify
the floor priority by editing the elevator floors menu (see Fig. 4.23).

4.3.2 STEPS

STEPS 5.1 (Simulation of Transient and Pedestrian movementS) is a commercial
fine network model developed by the Mott Macdonald simulation group (Mott
MacDonald Simulation Group 2012). STEPS uses potential maps to calculate the
movement of the agents towards the exits. The model also allows the simulation of
user-defined routes through the use of checkpoints. Several individual characteris-
tics can be assigned to the agents, such as unimpeded walking speeds, pre-evacuation

Floor	Delay	Open+Close Time	Pickup Time	Discharge Time
Floor 689,0 ft	0,0 s	7,0 s	86,0862 s	86,0862 s
Floor 702,0 ft	0,0 s	7,0 s	87,6712 s	87,6712 s
Floor 715,0 ft	0,0 s	7,0 s	89,2561 s	89,2561 s
Floor 728,0 ft	0,0 s	7,0 s	90,8411 s	90,8411 s
Floor 741,0 ft	0,0 s	7,0 s	92,4261 s	92,4261 s
Floor 754,0 ft	0,0 s	7,0 s	94,011 s	94,011 s
Floor 767,0 ft	0,0 s	7,0 s	95,596 s	95,596 s
Floor 780,0 ft	0,0 s	7,0 s	97,1809 s	97,1809 s
Floor 793,0 ft	0,0 s	7,0 s	98,7659 s	98,7659 s
Floor 806,0 ft	0,0 s	7,0 s	100,351 s	100,351 s
Floor 819,0 ft	0,0 s	7,0 s	101,936 s	101,936 s

Fig. 4.23 Screenshot of the "elevator levels" input menu in Pathfinder. The values in the figure are not representative of the model input configuration

times, awareness, patience, etc. The likelihood of the agents to wait in a queue is determined by their patience coefficient. The model permits to represent the interactions between horizontal and vertical components.

Stairs in STEPS

There are two different methods to simulate stairs in STEPS. A possible method is the use of the stair menu (see Fig. 4.24). This menu permits to define the geometric characteristics of the stairs (e.g., width, height, handrails, walking side, etc.), although the evacuation efficiency of the stair will be dependent on the assigned flows and speeds. It is also possible to decide if the stair is available only in one direction or if it allows counter-flows. The main parameter affecting the evacuation efficiency is the capacity factor (the model considers by default the values provided by NFPA 130 (NFPA 2010)). This option indicates that the capacity for stairs in NFPA 130 is used for stairs over or under 4 % of slope in the up or down direction. Users can also modify this default setting with the desired flows and speeds through stairs.

An alternative method is the definition of a plane with the shape of the stair under consideration. This method is particularly effective when the shape of the stair is not conventional (e.g., spiral stairs). The flows through stairs are imposed by the user in relation to the admitted flows through the stairs, i.e. imposing the capacity of the stairs and the speeds of the occupants. Also in this case, the default setting employed by the model for stairs is the one provided by NFPA 130, i.e., the values for a ramp slope > or < 4 % up and down. Model users can also modify this default setting with the desired flow through stairs.

Fig. 4.24 Screenshot of the input menu in STEPS about stairways. The values in the figure are not representative of the model input configuration

Elevators in STEPS

STEPS embeds an elevator sub-model. Evacuation elevators can be represented through a series of attributes concerning the kinematic, physical, and operational factors. The default settings of the model simulate the behaviours of the agents with no explicit user control on the percentage of agents using the elevators on a given floor

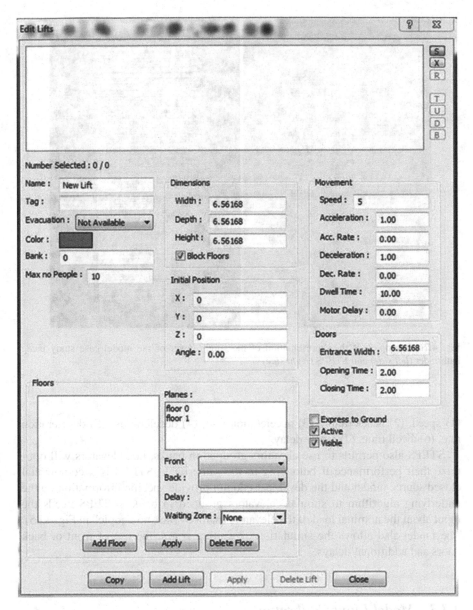

Fig. 4.25 Screenshot of the elevator input menu in STEPS. The values in the figure are not representative of the model input configuration

or their accepted waiting time for the elevators. Nevertheless, human factors can be represented implicitly by implementing waiting zones, patience coefficients, predefined paths, conditional rules, etc. The user needs to provide the geometric characteristics of the elevator such as elevator width, depth, height, door width (see Fig. 4.25). Then the user needs to define the opening and closing time. Other features include

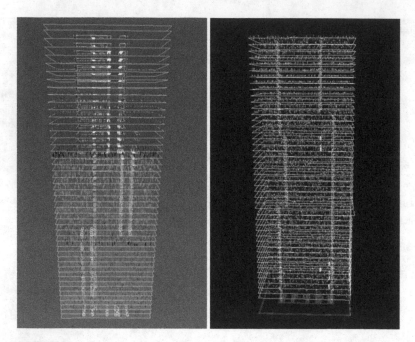

Fig. 4.26 Examples of the representation of the single tower of the model case study using Pathfinder (*left side*) and STEPS (*right side*)

(1) speed, (2) acceleration, (3) acceleration rate, (4) deceleration, (5) deceleration rate, (6) dwell time, (7) motor delay.

STEPS also permits to use elevators grouped in banks, i.e., elevators will optimize their performance if belonging to the same bank. STEPS is a commercial closed source model and the developers do not provide specific information on the underlying algorithm to simulate elevators grouped in banks. STEPS needs the input about the nominal load of the elevators (named "Max no People" in Fig. 4.25). The model also allows the simulation of waiting zones, the use of front or back doors and additional delays.

4.3.3 Model Input Calibration

This section provides information about the calibration of the input of the two egress models employed in this study, namely Pathfinder and STEPS. In particular, this section presents a detailed description of the methods employed to model the two main types of egress components of the model case study under consideration, i.e., stairs and elevators. The geometry has been represented within the two models in accordance with the description provided in the previous sections (see Fig. 4.26).

Stair Modelling

Stairs have been represented in the two models in accordance with the layout described in Section 2. The geometric characteristics in terms of riser, tread and width have been implemented in Pathfinder. This data are required by the model to calculate the final speeds and flows of the agents along the stairs in accordance with the equations by Gwynne and Rosenbaum (2008). In contrast, the representation of the stairs within STEPS has been made through the use of planes. The simulated planes represent the slopes and the landing corresponding to the stairs. The representation of the flows through stairs has been made through the implementation of restricted flows, employing the capacity factor. STEPS allows setting the maximum flow in a plane/exit. In the current study, the maximum flow in stairs has been calculated in accordance with the equations provided by Gwynne and Rosenbaum in the SFPE Handbook (2008). Restricted flows have been therefore implemented at each floor-to-stair connection.

It is also important to mention how the two models deal with merging flows in stairs, i.e. the conflict between agents coming from the stairs and agents coming from the floors. This is in fact one of the key aspects to be considered for the calculation of evacuation times in high-rise building stairway evacuations (Galea et al. 2008b). According to experimental observations (Boyce et al. 2009), the merge ratio should be approximately 50:50.

Pathfinder includes a mechanism that automatically solves agent potential conflict scenario (Thunderhead Engineering 2012). When an agent identifies a conflict in its desired direction, it can obtain a *free pass* during its movement. This free pass will avoid the simulation of non-realistic behaviours of the agents, i.e. agents in the stairs not allowing any agent in the floors to get into the stairs. The movement algorithm in STEPS includes different variables employed to solve this issue. The movement of the agents in STEPS is simulated using a recursive algorithm which simulates a potential map. This map is updated during the passage of time in order to take into account of the presence of other agents. The model also embeds a function able to adjust the queuing time in order to take into consideration the movement of the other agents.

Elevator Modelling

The calibration of the elevator sub-models is made by taking into consideration the main human factors involved. In particular, there is a need to assess the percentage of agents using the elevators in relation to the floor in which they are located at the beginning of the simulation and the time they are willing to wait for elevators before re-directing their movement towards the stairs.

The main available experimental data on the topic have been reviewed, namely the data-sets collected by Heyes (2009), Jönsson et al. (2012), and Kinsey (2011). With regards to the evacuees' choice about the elevator or stair usage, the two data-sets by Heyes (2009) and Jönsson et al. (2012) both provide linear correlations,

Table 4.6 Correlations of elevator usage in relation to the floor in which the occupant is located

Correlations of elevator usage vs floor[a]		
Heyes (2009)	Jönsson et al. (2012)	Kinsey (2011)
$P = 1.14\,F + 5.3$	$P = 0.84\,F + 1.05$	$P = 0.3207\ln(F) - 0.4403$

P percentage of occupants using the elevators, F floor in which the occupant is located

[a]The three correlation are suggested for different floor ranges: Heyes: $5 \leq F \leq 60$; Jönsson et al: $5 < F < 24$; Kinsey: $5 \leq F \leq 55$

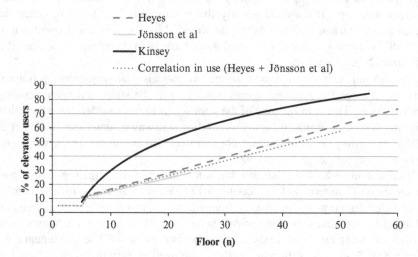

Fig. 4.27 Graphic representation of the correlations of elevator usage in relation to the floor by Heyes (*blue*), Jönsson et al. (*red*), Kinsey (*green*), and the new correlation in use (*purple*) for the first 25 floors (Color figure online)

while Kinsey's correlation embeds an exponential increase of lift usage. It should also be noted that the three data-sets are based on different types of studies and they have different assumptions/limitations, i.e., they are either based on online behavioural intention surveys (Kinsey 2011), on-site behavioural intention questionnaires (Jönsson et al. 2012) or simulation questionnaires and online surveys based on actual evacuation events (Heyes 2009). The three equations provided by the authors of the studies are provided in Table 4.6.

The correlations provided by Heyes (2009) and Jönsson et al. (2012) are both linear and the calculated elevator usage provided is very similar. For this reason, the results of these two correlations have been used in order to obtain a single average correlation for the calibration of the model input. Figure 4.27 shows the percentage of elevator users provided by the three correlations and the new merged correlation in use (in purple) for the first 25 floors.

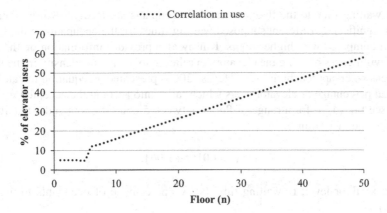

Fig. 4.28 The graph shows the new correlation of elevator usage in relation to the floor (50 floors)

As stated by Jönsson et al. (2012), the correlation in use should also consider the percentage of the evacuees that are unable to use the stairs during the evacuation. This issue is important mainly on the first 5 floors because the proportion of people who are not able to walk down the stairs is higher than the values provided by the correlation in use in these floors. For this reason, the percentage of evacuees using the stairs is essentially determined by this issue in the first 5 floors.

It should also be noted that the range of applicability of Jönsson et al. (2012) data-set is up to floor 24. The correlation has been therefore extended using the available data-sets in order to cover the range of floors of the model case study under consideration (i.e., 50 floors in total). The final correlation in use is presented in Fig. 4.28.

The second behavioural factor that has to be taken into consideration during the simulation of elevator usage is the maximum time that the occupants are willing to wait for elevators (among the percentage of elevator users) before re-directing their route and evacuating using the stairs. Also in this case, the three main data-sets on this issue are provided by Heyes (2009), Jönsson et al. (2012), and Kinsey (2011). Unfortunately, the scatter of the results is high and there is still a need to collect more behavioural data. It is important to note that the accepted waiting time for elevators is dependent on many factors such as the signage and the messaging strategies adopted in the building (Kuligowski and Hoskins 2012).

Although the studies on this issue are scarce, important information can be extracted by the available data-sets in order to calibrate the input of the model. The available data-sets all show that almost all the occupants are not willing to wait for elevators more than 10 min. The results provided in the studies show different degrees of dependency of the waiting time to the floor where the occupants are located. In particular, the study by Jönsson et al. (2012) states that the dependencies of the maximum waiting time to the floor is almost negligible in the collected data-set. It is argued that this is due to the lower number of floors considered in the study (24 floors). Heyes (2009) and Kinsey (2011) data-sets shows instead the dependency

of the waiting time to the floors where the occupants are located. Kinsey data-set shows significantly different supposed waiting times for the occupants of the floors 2–10 if compared with higher floors. Kinsey also provides information on the supposed willingness of using the elevators in relation to the people density in the waiting areas when approaching them. Heyes (2009) presented an equation to calculate the final percentage of elevator users which takes into account the accepted waiting time (see Eq. (4.2)) for a range of floors between 5 and 60 floors and a maximum waiting time of 10 min.

$$y = \left(-0.0016t + 1.06\right)x \qquad\qquad (4.2)$$

where: x = floor level; t = waiting time (s); y = percentage of occupants to use the lift (%).

The methods employed by evacuation models to represent elevator human factors are often not explicit and the user has to make a set of assumptions to simulate the above mentioned behavioural factors. The percentage of occupants using a vertical egress component can be explicitly modelled in the tools employed (both Pathfinder and STEPS) using the correlation described in Fig. 4.28. In contrast, the evacuation models in use are not fully able to explicitly represent the maximum accepted elevator waiting times. The modeller has therefore to make an additional calibration effort to simulate this type of behaviour.

A maximum acceptable time of 10 min has therefore been assumed (in accordance with the three data-sets today available) and agents have been split into two groups, namely (a) agents staying 300 s in the elevator waiting zone before re-directing their movement towards the stairs and (b) agents staying 600 s in the elevator waiting zone before re-directing their movement towards the stairs. The calibration of waiting times has been made in accordance with Heyes's (2009) studies (see Eq. (4.2)), adapted to the new correlation presented in Fig. 4.28. The final calibration about the agents' egress components choice is based therefore on the assumption that there are almost no occupants willing to wait more than 600 s for elevators.

Agents and Behavioural Modelling

This section presents the modelling assumptions made in the simulation of the agent and the behaviours represented. The information provided deals with the characteristics of the population, i.e., unimpeded walking speeds, body dimensions of the agents, behavioural modelling and the response time.

The assumed population in the building is 182 agents per office floor for a total of 8,372 occupants. This population is lower than the value provided in the IBC (2012) and NFPA101 (NFPA 2012a, b). This assumption is made in order to provide a more realistic occupant load in the case of total evacuation (Muha 2012). It also reflects the assumed population made by elevator practitioners in the calculation of elevator diagrams. Walking speeds are inserted in accordance with the default data employed by Pathfinder. This input is based on Gwynne & Rosenbaum's chapter (2008) in the Society of Fire Protection Engineering Handbook. The assumed

Table 4.7 Unimpeded walking speeds for people with locomotion disabilities (Boyce and Shields 1999)

People with locomotion disability		
Mean (m/s)	SD (m/s)	Range (m/s)
0.8	0.37	0.1–1.68

speeds are normal distributions with an average unimpeded walking speed of 1.19 m/s (3.9 ft/s) and a standard deviation of 1.0 m/s (3.3 ft/s). Walking speeds are then automatically adjusted by the models during the simulation in relation to people density, properties of the elements of the geometry (i.e., horizontal or vertical egress components), etc. It is also known that some occupants may present physical impairments and therefore they may have reduced horizontal and vertical speeds (Boyce and Shields 1999). For this reason, 5 % of the population of the building has been considered with movement disabilities (Jönsson et al. 2012). The assumed distribution for this type of occupants is based on the data-set collected by Boyce and Shields (1999) (see Table 4.7). One of the assumptions of this study is that the population with physical impairment is evenly distributed into the total population of the building and evacuate in an evenly distributed manner.

The default distribution employed by Pathfinder has been used in the model configuration with regards of the dimensions of the agents. STEPS is a fine network model, thus this parameter is not relevant since the key factor affecting this issue is the type of grid employed.

The behaviours of the agents are classified into three main categories, namely (1) agents using elevators, (2) agents using stairs, and (3) agents going towards the elevator waiting area and after reaching their maximum accepted waiting time for elevators, they redirect their movement towards stair. The calibration of behaviour (3) is simulated explicitly by applying the experimental data presented in the previous paragraph. This has been implemented within the model by simulating two sub-behaviours, i.e. either waiting 300 or 600 s before re-directing the movement towards stairs.

Pre-evacuation delay times are implemented within the models after a review of the main available data-sets. Given the objectives of the project, an attempt to reproduce realistic pre-evacuation delays has been made by using the available actual data on high-rise building evacuations. The main real world data-set for high-rise building evacuation is coming from the evacuation of the World Trade Centre (Averill et al. 2005).

Several studies (Fahy 2012; Galea et al. 2008a; Kuligowski and Mileti 2009; McConnell et al. 2010; Sherman et al. 2011) have been made to investigate the pre-evacuation response phase of the World Trade Centre evacuation. The information provided in the above mentioned studies have been adopted to simulate the pre-evacuation response phase in this study. In line with the collected information, the simulated average response time is 6 min. The studies from Purser and Bensilum (2001) demonstrate that an appropriate representation of pre-evacuation times can be made through the use of log-normal distributions. In accordance with these assumptions, the implemented delay is represented using a truncated log-normal distribution with the values provided in Table 4.8.

Table 4.8 Pre-evacuation
delays employed in the
simulations

Mean	360 s
Standard Deviation	120 s
Min	180 s
Max	600 s

4.3.4 Model Results

The results of the models are presented in this section. It should be noted that although
an attempt to calibrate the model using the same input has been made (the simulation
method is a specified calculation (Lord et al. 2005)), the models present some intrin-
sic characteristics that required the use of different input configurations. This is a key
point that needs to be highlighted prior to read the analysis of the results.

The analysis of the results is divided into two groups:

1. A cross comparison of the results of two different models (STEPS (Mott
 MacDonald Simulation Group 2012) and Pathfinder (Thunderhead Engineering
 2012)) employed for simulating the evacuation using a single vertical egress
 component (either stairs or OEEs).
2. A relative comparison of all the evacuation strategies. This comparison is made
 employing a single evacuation model (Pathfinder).

The first group of results is a cross comparison of the evacuation scenarios simu-
lated employing two evacuation models, namely STEPS and Pathfinder. The strate-
gies simulated using both STEPS and Pathfinder have been selected in order to
compare the underlying algorithms embedded in the models. In particular, the sub-
models employed to simulate vertical components have been compared, namely
stairs (Strategy 1) and OEEs (Strategy 4). The scope was to evaluate the range of
variability of the results between the two models.

The second step of the analysis is the relative comparison between different evac-
uation strategies. The evacuation strategies have been simulated using a single model
(Pathfinder). The scope of this analysis is to rank the effectiveness of different evacu-
ation strategies in relation to the evacuation times produced by the egress model.

Results are presented by plotting the number of evacuees against the passage of
time. The percentages presented are respectively 25 %, 50 %, 75 %, 98 % and
100 % of the total number of occupants initially in the building. Those percentages
have been selected in order to be representative of different equal parts of the evacu-
ation process (25 %, 50 %, 75 %, and 100 %) and then show the impact of slow
occupants on the simulated total evacuation time (98 vs 100 %). The analysis of the
selected percentages of evacuees allows understanding the evacuation process and a
global picture on the effectiveness of the strategies during the passage of time.

Evacuation models often embed stochastic variables to reproduce some particu-
lar aspect of the evacuation process, e.g. pre-evacuation time distributions, unim-
peded walking speeds, etc. The two evacuation models employed in this study were
no exception. For this reason, it is necessary to define the appropriate number of
runs to be simulated in order to avoid that the results of the models would be affected

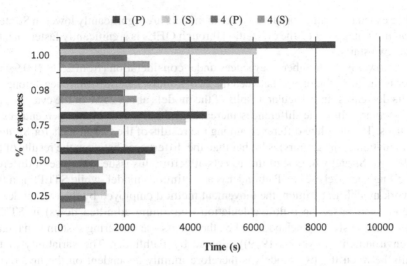

Fig. 4.29 Percentages of evacuees against time for Strategy 1 and Strategy 4. *(P)*Pathfinder results, *(S)* STEPS results

by the number of simulations. A convergence method (convergence in mean) was therefore employed. The method consists of the analysis of the averaged evacuation times produced in consecutive runs. The evacuation time used as reference was the time referred to the 98 % of the evacuees as it has been shown that the results of the 100 % of the agents in some models can be dependent on the limitations inhered to a specific model (Frantzich et al. 2007). In the results presented, the number of simulations of the same scenario is dependent on the error of two consecutive averaged evacuation times of the 98 % of the evacuees. The runs are stopped when the error is lower than 1 %, i.e., an additional run would change the results of less than 1 %. The adopted method has been chosen in order to control the variability of the evacuation times in relation to the simulated number of runs, although several factors may contribute on the simulation of evacuation times. A minimum number of runs for the selected scenarios has been employed (20 runs) but the exact number of runs have been calculated using the convergence criteria. The choice of the convergence method is deemed appropriate when related to the intrinsic uncertainties associated with evacuation models.

Variability of Model Results

This section presents the cross comparison between the model results for Strategy 1 (2 stairs are available for the evacuation) and Strategy 4 (only OEEs are available for the evacuation). An evaluation of the results has been made in order to analyse the variability of the results under the modelling assumptions employed. Figure 4.29 shows the results employing Pathfinder and STEPS, respectively (P) and (S) in Fig. 4.29.

The evacuation times produced by both models are significantly lower in Strategy 4 than in Strategy 1, i.e., the evacuation through OEEs is significantly faster than the use of two stairs.

The lower is the number of evacuees under consideration (from 25 to 100 %) the better is the fit of the results between the two models, i.e., the difference among the results decreases. In particular, results of the models about 25 % of the evacuees are very similar, while the differences increase gradually with higher percentages of evacuees. The absolute difference among the results of the two models for Strategy 1 (evacuation using 2 stairs) is higher than the differences between the results of the models for Strategy 4. One of the aspects affecting this issue is the use of different modelling approaches, i.e., Pathfinder is a continuous model, while STEPS is a fine network model. In addition, the movement method employed by the two models is different and based on a flow calculation (maximum admitted flows) in STEPS rather than the steering behaviours (i.e., the agents use a steering system to navigate the environment (Reynolds 1999)) adopted by Pathfinder. The variability of the results between the two models is therefore mainly dependent on the underlying algorithms employed by the models.

The simulations of Strategy 4 shows that the absolute differences in terms of evacuation predictions are significantly lower than in Strategy 1, i.e., the elevator sub-models of the two models provide a lower range of results variability. This is related to the method employed to simulate the egress through elevators, i.e., the same variables have been employed in both models to simulate the evacuations using OEEs. In this case, the results provided by STEPS are higher than the results provided by Pathfinder.

The results of the simulations allow making a relative comparison of different strategies employing one of the two models, i.e., the range of variability of the results permits the performance of a relative analysis of the strategies employing different egress components.

Relative Comparison of Evacuation Strategies

The relative comparison of evacuation strategies has been performed using Pathfinder. All strategies (seven) have been simulated and the results have been compared. Results are presented using a scatter plot (Fig. 4.30) and a histogram (Fig. 4.31). This choice is based on the fact that the scatter plot allows understanding the trend of the evacuation processes, while the histogram allows a better visualization of the differences in terms of evacuation times among the strategies employed. Also in this case, the absolute differences among the different strategies increase with the percentage of evacuees under consideration.

Strategy 1 (i.e. two stairs are available for the evacuation) provides the longest evacuation times for all the percentage of evacuees under consideration (see the blue diamonds in Fig. 4.30 and the blue column in Fig. 4.31). As expected, the use of an additional third stair (Strategy 2) provides a significant reduction in the evacuation times (see red squares in Fig. 4.30 and red column in Fig. 4.31) if compared with Strategy 1. The position of the stairs in the model case study is almost sym-

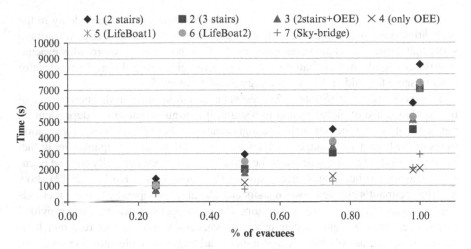

Fig. 4.30 Percentages of evacuees against the passage of time employing Pathfinder for all evacuation strategies

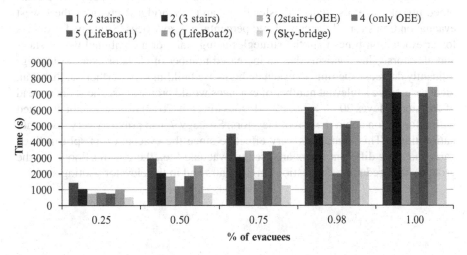

Fig. 4.31 Histogram about the percentages of evacuees against the passage of time employing Pathfinder for all evacuation strategies

metric, thus stair usage is distributed among the stairs. This is reflected in the fact that disproportional stair usages do not take place.

The combined use of stairs and elevators (strategy 3) provides results approximately in the same range of Strategy 2 (see the green triangles in Fig. 4.30 and the green column in Fig. 4.31). The use of the "life-boat" strategies (Strategy 5 and Strategy 6) does not provide differences in the results if compared with Strategy 3 (see Figs. 4.30 and 4.31). This may be dependent on different issues. In the case of strategy 6, the mid-rise elevator bank is not serving the mid-rise bank (they are employed as shuttles in the transfer floors), thus forcing all the evacuees in that zone to use stairs.

The use of the mid-elevator bank as shuttle elevators may create a delay in the evacuation process if compared with strategies employing the mid-rise elevators to serve that zone. This is also confirmed by the fact that strategy 6 provides evacuation times slightly higher than the other two strategies using the mid-rise elevator bank to serve the mid-rise zone (Strategy 3 and Strategy 5).

Life-boat strategy 1 (Strategy 5) presents evacuation times in the same range of the combined use of elevators and two stairs. It is argued that this is dependent on the fact that both strategies include a significant number of stair users. Evacuation times of the higher percentage of evacuees (e.g., 98 % of the occupants) are in fact mainly dependent on the stair users, i.e. slow stair users are generally the last occupants leaving the building. Current studies (Kuligowski and Hoskins 2012) show that the occupant's choice between stairs and elevators is dependent on the methods adopted to encourage the use of elevators. If no appropriate information is provided to the occupants, a significant number of evacuees would in fact re-direct their movement to the use of stairs even if their initial target is an elevator (Heyes 2009; Kinsey 2011; Jönsson et al. 2012). This is the case of the simulations under consideration in the present study.

Strategy 4 (only OEEs are available for the evacuation) and Strategy 7 (the combined use of elevators, stairs, transfer floors and sky-bridges) provides the lowest evacuation times for all the considered percentage of evacuees. Strategy 4 provides lower evacuation times than the strategies using stairs or a combined use of stairs and elevators. This confirms that an increased number of elevator users would significantly decrease the time to evacuate high-rise buildings. Nevertheless, this is an ideal case, since a relevant number of evacuees would prefer to use the stairs instead of elevators (Heyes 2009; Kinsey 2011; Jönsson et al. 2012) if they are not provided with information about the use of elevators. Strategy 7 also provides very low evacuation times. This strategy is very effective since the evacuation is split in three parts and three different floors are used to evacuate (i.e., the transfer floors and the ground), thus reducing congestions in the stairs and in the elevator waiting areas.

Chapter 5
Discussion

Egress modelling has been successfully employed to perform a study on the effectiveness of different evacuation strategies in the case of high-rise building evacuations. The cross comparison between the results provided by the models for the simulation of different egress components allows understanding the range of variability of the results. The analysis of the results has therefore led to a relative comparison between different strategies for total evacuation.

The present study extends the current understanding on the effectiveness of different total evacuation strategies in high-rise buildings by providing a comparison of strategies which include the combined use of vertical and horizontal egress components. In addition, the potential effectiveness of sky-bridges – an egress component which has not been fully investigated in previous modelling research – has been analysed.

The models under consideration (Pathfinder and STEPS) employ different sub-models to simulate the evacuation process using stairs or elevators. A single model is often employed indiscriminately by practitioners to assess the safety of high-rise buildings when using the performance based design approach (Ronchi and Kinsey 2011). Inexpert model users may not be aware of the differences deriving from the intrinsic assumptions of the models. Users should instead use methods to tackle the uncertainties deriving from the modelling assumptions, i.e., sensitivity analyses, safety factors, etc. in order to obtain reliable quantitative results (Ronchi 2012). In the current study, model results have been successfully used to qualitative rank different evacuation strategies, although results are not employed in this study from a quantitative point of view given the lack of knowledge of the fire safety research community on the actual behaviours during high-rise building evacuations.

Results show that the use of two stairs (Strategy 1) for high-rise building evacuations provide higher evacuation times compared with any other strategy employed. Results about the evacuation time using three stairs or a combination of elevators and stairs present lower results than the use of two stairs. The use of three stairs or a combined use of stairs and elevators presents evacuation times in approximately the same range. This confirms the requirement of the International Building Code

E. Ronchi and D. Nilsson, *Assessment of Total Evacuation Systems for Tall Buildings*, SpringerBriefs in Fire, DOI 10.1007/978-1-4939-1074-8_5, © Fire Protection Research Foundation 2014

(IBC 2012) about the third stairway for buildings over 128 m that are not provided with OEEs (IBC, 403.5.2 and 3008.1.1). NFPA101 (NFPA 2012a, b) currently does not automatically require the third stair (NFPA 101 7.14.1.3). Three (or more) stairs may be required in relation to occupant loads and travel distance. There is therefore the need to evaluate the possibility of adopting in NFPA101 the prescription of a third means of escape, and discuss about the possible egress component(s) to be used, i.e., either a third stair, the use of OEEs or sky-bridges.

In particular, the use of OEEs in a total evacuation strategy for this 50 storey case study high-rise building provided a great advantage for the entire population, including people with disabilities. This issue has already been highlighted by actual evacuation such as in the terrorist attack of the World Trade Center (Shields et al. 2009). Nevertheless, an important limitation of evacuation models is that they generally simulate people with disabilities in a simplistic manner (i.e. agents with a reduced speed) and there is a need to take into account this limitation when analysing model results. In addition, the current capabilities of evacuation models are not enhanced to consider the variability of the impairments and their subsequent effects on the evacuation process.

The effectiveness of the strategies including elevator and stair usage is strictly linked to the information provided to the occupants and the accepted occupant waiting time for elevators. There is a need to adopt solutions able to increase the likelihood of the occupants to wait longer for elevators in order to optimize the efficiency of the strategies involving elevators. The current maximum waiting time for elevator (approximately 10 min) substantially affects the effectiveness of the strategies employing OEEs as egress components. The individual use of OEEs for elevators provides in fact the lowest evacuation times, although it represents at the moment an ideal case. Elevator signage and elevator messaging strategies are therefore a key issue that needs to be further investigated by the fire research community and that need to be fully addressed by legislators.

The strategy employing the use of transfer floors and sky-bridges (Strategy 7) is also an ideal case. In fact, there is a lack of knowledge about the behaviours of evacuees in the case of evacuation using sky-bridges. Results show that it may potentially be very effective although there is a need to further analyse the actual behaviour of the evacuees in the case of evacuation at height. It should also be noted that this strategy has been tested for the evacuation of a single tower. The bomb scare of the Petronas Towers (embedding a sky-bridge) the day after the events of 09/11 showed that the evacuation through sky-bridges may not be effective in the case of a contemporary total evacuation of two towers (Ariff 2003; Bukowski 2010). In fact, occupants of both towers located above the sky-bridge may try to evacuate through the bridge, thus causing contraflows and congestions. Training and education on the use of these systems is therefore a key issue to be investigated.

The evacuation of a single tower using a strategy adopting sky-bridges resulted as a potentially very effective strategy, although it is an ideal case. In fact, there is a need to further analyse the actual behaviours of the evacuees in the case of evacuation at height. This type of strategy is currently not explicitly considered in NFPA101. In order to improve occupant life safety in high-rise buildings, it is also

necessary to investigate the effectiveness of this strategy given different sky-bridge configurations (their position, numbers, etc.) and building layouts.

The reader of the results of this study needs to carefully consider the assumptions made during the modelling work. Modelling results are in fact dependent both on the limitations of the modelling tools employed (e.g., models do not represent fatigue, the representation of the behaviours of people with disabilities is very simple, etc.) and the assumptions made (e.g., the sky-bridge scenario is an ideal case in which only the evacuation of one tower has been considered, the representation of the choice between different egress components is based on a limited number of experimental data-sets, etc.). Nevertheless, the current study showed that evacuation modelling tools can be effectively employed to qualitatively rank different total evacuation strategies in high-rise buildings.

Chapter 6
Future Research

The analysis of the egress modelling results shows that there is a need to further investigate human factors associated with the use of combined egress components, e.g. messaging strategies for encouraging elevator usage. This would significantly improve the effectiveness of the strategies employing a combination of stairs and elevators. In a more general sense, there is a need to analyse more in depth the behaviours of the evacuees in relation to multiple egress components available for the evacuation and analyse the methods to inform evacuees on the appropriate actions to perform. The simulation work showed that the most effective strategies for this 50 storey building (the sole use of OEEs and the use of sky-bridges and transfer floors) are hypothetical strategies that are generally not implemented in today's high-rise buildings. This also confirms previous findings by Kinsey (2011) which highlighted that the use of transfer floors produced the most efficient evacuation strategies due to the reduced waiting time period to use elevators. The exclusion of those strategies may be due to a lack of understanding regarding the behaviours of building occupants in the case of non-conventional strategies. An example is that some occupants may be afraid of height, leading them to avoid the use of sky-bridges. In this context, there is a need to investigate several variables such as the occupant level of training, the availability of staff, the type of population (e.g. different percentages of people with disabilities and types of disabilities, etc.), occupant loads, etc.

The current model case study represents a realistic configuration of today's high-rise buildings. Nevertheless, there is a need to investigate a broader range of building heights and configurations. This would include the study of different building uses (the model case study has business use) such as residential buildings, health care facilities, etc. The geometric layout of the building is also a crucial variable. There is the need to investigate different building configurations, e.g. different location and characteristics of the egress components (e.g., stair design and location, elevator zoning, number and position of the sky-bridges, etc.), number of floors, building heights, etc.

E. Ronchi and D. Nilsson, *Assessment of Total Evacuation Systems for Tall Buildings*,
SpringerBriefs in Fire, DOI 10.1007/978-1-4939-1074-8_6,
© Fire Protection Research Foundation 2014

The present work highlights the lack of experimental/actual data about the behaviours of the occupants in the case of a combined use of different egress components. The calibration of the modelling input has been made with the currently available data (Heyes 2009; Kinsey 2011; Jönsson et al. 2012), although further research on the occupant's decision making process about the choice between multiple egress components would permit to reduce the variability in model results.

Another important issue is the accuracy of the evacuation model predictions. This is mainly connected to the availability of experimental data to calibrate the input. To date, a possible method to increase the quantitative reliability of model results is the use of a multi-model approach. The benefits of this method have been already tested for other type of environments, e.g. road tunnels (Ronchi 2012), and they could be potentially extended to high-rise building evacuations. This approach is based on the use of several evacuation models to simulate the same scenario. This method can be used to perform a detailed investigation on the modelling assumptions employed by each model, e.g., default settings, modelling methods, etc. and identifying the sources of the differences in model results. The models are then used at their best through an iterative process of calibration of the inputs in relation to the degree of accuracy of the models in representing a specific aspect of the evacuation process. The definition of the benchmark model(s) for the different aspects of evacuation may rely either on the absence of a sub-model in a tool or on the comparison between each model and experimental data.

Chapter 7
Conclusion

The present study employed egress modelling tools to investigate the effectiveness of different evacuation strategies for high-rise buildings. Two evacuation strategies resulted as the most efficient, i.e. the sole use of Occupant Evacuation Elevators and the strategy employing a combined use of vertical (stairs and elevators) and horizontal egress components (transfer floors and sky-bridges). The effectiveness of the strategies employing a combined use of elevators and stairs is dependent on the information provided to the evacuees. In fact, if no appropriate information is provided to the occupants, a significant percentage of evacuees may re-direct their movement to stairs after a maximum time waiting for elevators. The study highlighted the need for further studies on the behaviours of the occupants in the case of a combined use of egress components in relation to different building configurations and egress component layouts.

E. Ronchi and D. Nilsson, *Assessment of Total Evacuation Systems for Tall Buildings*, 45
SpringerBriefs in Fire, DOI 10.1007/978-1-4939-1074-8_7,
© Fire Protection Research Foundation 2014

Appendix

Summary of the characteristics the model case geometry, i.e., floor to floor distances, their designated use and the floor numbering (roof-floor 18).

Description	Floor	Height (m)	Height (feet)	Floor to floor distance (m)	Floor to floor distance (feet)	Comments
ROOF	roof	206.7	678	6	20	
MEP	50	200.6	658	6	20	EMR
MEP	49	194.5	638	4	13	EMR
Office/High	48	190.5	625	4	13	
Office/High	47	186.5	612	4	13	
Office/High	46	182.6	599	4	13	
Office/High	45	178.6	586	4	13	
Office/High	44	174.7	573	4	13	
Office/High	43	170.7	560	4	13	
Office/High	42	166.7	547	4	13	
Office/High	41	162.8	534	4	13	
Office/High	40	158.8	521	4	13	
Office/High	39	154.8	508	4	13	
Office/High	38	150.9	495	4	13	
Office/High	37	146.9	482	4	13	
Office/High	36	143	469	4	13	
Office/High	35	139	456	4	13	EMR
Office/High	34	135	443	4	13	EMR
Office/Trans M_H	33	131.1	430	4	13	
Office/Mid	32	127.1	417	4	13	
Office/Mid	31	123.1	404	4	13	
Office/Mid	30	119.2	391	4	13	
Office/Mid	29	115.2	378	4	13	
Office/Mid	28	111.3	365	4	13	
Office/Mid	27	107.3	352	4	13	
Office/Mid	26	103.3	339	4	13	

(continued)

E. Ronchi and D. Nilsson, *Assessment of Total Evacuation Systems for Tall Buildings*,
SpringerBriefs in Fire, DOI 10.1007/978-1-4939-1074-8,
© Fire Protection Research Foundation 2014

(continued)

Description	Floor	Height (m)	Height (feet)	Floor to floor distance (m)	Floor to floor distance (feet)	Comments
Office/Mid	25	99.4	326	4	13	
Office/Mid	24	95.4	313	4	13	
Office/Mid	23	91.4	300	4	13	
Office/Mid	22	87.5	287	4	13	
Office/Mid	21	83.5	274	4	13	
Office/Mid	20	79.6	261	4	13	EMR
Office/Mid	19	75.6	248	4	13	EMR
Office/Trans L_M	18	71.6	235	4	13	

Legend: Office/Trans L_M transfer floor from low-rise to mid-rise zone with office use, *Office/Mid* mid-rise floor with office use, *Office/Trans M_H* transfer floor from mid-rise to high-rise zone with office use, *Office/High* high-rise floor with office use, *MEP* mechanical, electrical and plumbing floor, *ROOF* top of the building, *EMR* elevator machine rooms

Summary of the characteristics the model case geometry, i.e., floor-to-floor inter-distances, their designated use and the floor numbering (floor 18-floor B3).

Description	Floor	Height (m)	Height (feet)	Floor to floor distance (m)	Floor to floor distance (feet)	Comments
Office/Trans L_M	18	71.6	235	4	13	
Office/Low	17	67.7	222	4	13	
Office/Low	16	63.7	209	4	13	
Office/Low	15	59.7	196	4	13	
Office/Low	14	55.8	183	4	13	
Office/Low	13	51.8	170	4	13	
Office/Low	12	47.9	157	4	13	
Office/Low	11	43.9	144	4	13	
Office/Low	10	39.9	131	4	13	
Office/Low	9	36	118	4	13	
Office/Low	8	32	105	4	13	
Office/Low	7	28	92	4	13	
Office/Low	6	24.1	79	4	13	
Office/Low	5	20.1	66	4	13	
Office/Low	4	16.2	53	4	13	
Office/Low	3	12.2	40	4	13	
Office/Low	2	7.1	20	6	20	
Lobby	1	0	0	6	20	
Parking/MEP	B1	−4.6	−15	4.6	15	
Parking/MEP	B2	−9.2	−30	4.6	15	
Parking/MEP	B3	−13.7	−45	4.6	15	

Legend: Parking/MEP parking/mechanical, electrical and plumbing floor, *Lobby* building lobby, *Office/Low* low-rise floor with office use, *Office/Trans L_M* transfer floor from low-rise to mid-rise zone with office use

References

Amor HB, Murray J, Obst O (2006) Fast, neat, and under control: arbitrating between steering behaviors. In: Rabin S (ed) AI game programming wisdom, 3rd edn, Cengage, pp 221–232

Ariff A (2003) Review of evacuation procedures for Petronas Twin Towers. In: Proceedings of the CIB-CTBUH International Conference on Tall Buildings, Kuala Lumpur. CIB Publication no:290

Averill JD, Mileti DS, Peacock RD, Kuligowski ED, Groner N, Proulx G, Reneke AP, Nelson HE (2005) Final report on the collapse of the world trade center towers. Federal building and fire safety investigation of the World Trade Center Disaster, Occupant Behaviour, Egress and Emergency Communications, September. NIST NCSTAR 1–7

Bazjanac V (1977) In: Conway DJ (ed.) Simulation of elevator performance in high-rise buildings under conditions of emergency, human response to tall buildings. Dowden, Hutchinson & Ross, Stroudsburg, PA, 316–328

Boyce KE, Purser D, Shields TJ (2009) Experimental studies to investigate merging behaviour in a staircase. In: Proceedings of the 4th International Symposium on Human Behaviour in Fire, Robinson College, Cambridge, 13–15 July 2009. Interscience Communications, pp 111–122

Boyce KE, Shields TJ (1999) Towards the characterisation of building occupancies for fire safety engineering: capabilities of disabled people moving horizontally and up an incline. Fire Technol 35(1):51–67

Bukowski RW (2010) Applications of elevators for occupant egress in fires. Fire Protect Eng Trends (38)

Fahy RFF (2012) Overview of major studies on the evacuation of World Trade Center Buildings 1 and 2 on 9/11. Fire Technol 49(3):643–655. doi:10.1007/s10694-012-0290-9

Frantzich H, Nilsson D, Eriksson O (2007) Utvärdering och validering av utrymningsprogram [Evaluation and validation of evacuation programs], Report 3143, Department of Fire Safety Engineering and Systems Safety, Lund University

Galea ER, Sharp G, Lawrence PJ, Holden R (2008a) Approximating the evacuation of the World Trade Center North Tower using computer simulation. J Fire Protect Eng 18(2):85–115

Galea ER, Sharp G, Lawrence P (2008b) Investigating the representation of merging behavior at the floor-stair interface in computer simulations of multi-floor building evacuations. J Fire Protect Eng 18(4):291–316

Gwynne SMV, Galea ER, Owen M, Lawrence PJ, Filippidis L (1999) A review of the methodologies used in the computer simulation of evacuation from the built environment. Build Environ 34(6):741–749

Gwynne SMV, Kuligowski E (2010) The faults with default. In Proceedings of the 12th Conference Interflam 2010, Interscience Communications Ltd, London, pp 1473–1478

Gwynne SMV, Rosenbaum E (2008) Employing the hydraulic model in assessing emergency movement. In: The SFPE handbook of fire protection engineering, 4th Edition. National Fire Protection Association, Quincy, MA, pp 3-396–3-373

Heyes E (2009) Human behaviour considerations in the use of lifts for evacuation from high rise commercial buildings. Phd dissertation. University of Canterbury, Christchurch, New Zealand

International Building Code (2012) International Code Council, Country Club Hills, IL 60478 and Building Construction and Safety Code

Jönsson A, Andersson J, Nilsson D (2012) A risk perception analysis of elevator evacuation in high-rise buildings. In: Proceedings of the 5th human behaviour in fire symposium, Cambridge (UK). Interscience Communication, London

Kinsey MJ (2011) Vertical transport evacuation modelling. PhD Dissertation. University of Greenwich, UK

Klote JH, Alvord DM (1992) Routine for analysis of the people movement time for elevator evacuation, National Institute of Standards, NISTIR 4730

Kuligowski ED, Mileti DS (2009) Modeling pre-evacuation delay by occupants in World Trade Center Towers 1 and 2 on September 11, 2001. Fire Safety J 44:487–496. doi:10.1016/j.firesaf.2008.10.001

Kuligowski ED, Peacock RD, Hoskins, BL (2010) A review of building evacuation models, 2nd edn. Technical Note 1680. NIST, Fire Research Division, Washington, US

Kuligowski ED (2011) Terror defeated: occupant sensemaking, decision-making and protective action in the 2001 World Trade Center disaster. Dissertation. University of Colorado

Kuligowski ED, Hoskins BL (2012) Recommendations for elevator messaging strategies. NIST report 1730

Lord J, Meacham B, Moore A, Fahy R, Proulx G (2005) Guide for evaluating the predictive capabilities of computer egress models, NIST Report GCR 06-886

Machado Tavares R (2009) Evacuation processes versus evacuation models: "Quo Vadimus'?". Fire Technol 45:419–430

McConnell NC, Boyce KE, Shields J, Galea ER, Day RC, Hulse LM (2010) The UK 9/11 evacuation study: analysis of survivors' recognition and response phase in WTC1. Fire Safety J 45:21–34

Mott MacDonald Simulation Group (2012) Simulation of Transient Evacuation and Pedestrian movementS STEPS User Manual, Version 5.1. Mott MacDonald Simulation Group

Muha T (2012) Evaluating occupant load factors for business operations. Fire Protection Research Foundation report

NFPA (2010) NFPA 130. Standard for fixed guideway. Transit and Passenger Rail Systems

NFPA (2012a) NFPA 101 Life Safety Code

NFPA (2012b) NFPA 5000. Building Construction and Safety Code

Purser DA, Bensilum M (2001) Quantification of behaviour for engineering design standards and escape time calculations. Safety Sci 30:157–182

Reynolds CW (1999) Steering behaviors for autonomous characters. Proceedings of the game developers conference 1999. Miller Freeman Game Group, San Francisco, California, pp 763–782

Ronchi E, Kinsey M (2011) Evacuation models of the future. Insights from an online survey on user's experiences and needs. In: Capote J, et al. (ed), Advanced research workshop evacuation and human behaviour in emergency situations EVAC11, Santander, pp 145–155.

Ronchi E (2012) Evacuation modelling in road tunnel fires. Phd Dissertation. Polytechnic University of Bari, Italy

Ronchi E, Nilsson D (2013a) Assessment of total evacuation strategies for tall buildings. Report 3168. Department of Fire Safety Engineering and Systems Safety, Lund University, Sweden

Ronchi E, Nilsson D (2013b) Fire evacuation in high-rise buildings: a review of human behaviour and modelling research. Fire Science Rev 2:7. doi:10.1186/2193-0414-2-7

Ronchi E, Nilsson D (2014) Modelling total evacuation strategies for high-rise buildings. Building Simul 7(1):73–87. doi:10.1007/s12273-013-0132-9

Ronchi E, Nilsson D, Gwynne SMV (2012a) Modelling the impact of emergency exit signs in tunnels. Fire Technol 48(4):961–988. doi:10.1007/s10694-012-0256-y

Ronchi E, Gwynne SMV, Purser DA, Colonna P (2012b) Representation of the impact of smoke on agent walking speeds. Fire Technol 49(2):411–431. doi:10.1007/s10694-012-0280-y

Sekizawa A, Nakahama S, Ebihara M, Notake H, Ikehata Y (2009) Study on feasibility of evacuation by elevators in a high-rise building. In: Proceedings of the 4th human behaviour in fire conference. Interscience Communication, London, pp 65–76

Sherman MF, Peyrot M, Magda LA, Gershon RRM (2011) Modeling pre-evacuation delay by evacuees in World Trade Center Towers 1 and 2 on September 11, 2001: a revisit using regression analysis. Fire Safety J 46(7):414–424

Shields TJ, Boyce KE, McConnell N (2009) The behaviour and evacuation experiences of WTC 9/11 evacuees with self-designated mobility impairments. Fire Safety J 44(6):881–893

Strakosch GR, Caporale RS (2010) The vertical transportation handbook. Wiley, New York, p 624

Thunderhead Engineering (2012) Pathfinder 2012.1.10802 Version. Technical Reference

Wong K, Hui M, Guo D, Luo M (2005) A refined concept on emergency evacuation by lifts. Proceedings of the eighth international symposium on fire safety science, pp 599–610